OUT OF GAS

OUT of GAS

PUMPS AND PICKUPS FROM THE GOLDEN AGE OF GAS

Jeffrey E. Blackman

THE COUNTRYMAN PRESS · WOODSTOCK · VT·

ISBN 978-0-88150-853-6

Book design and composition by Melanie Jolicoeur
All photographs by the author

Published by The Countryman Press, PO Box 748, Woodstock, VT 05091
Distributed by W. W. Norton & Company, Inc., 500 Fifth Avenue, New York, NY 10110

Manufactured in China

10 9 8 7 6 5 4 3 2 1

ACKNOWLEDGMENTS

I enjoyed a successful and wonderful experience with The Countryman Press during the production of my most recent book, *Covered Bridges of New England*, but as the price of gas increased dramatically, I realized as well that traveling to my publisher had become increasingly more expensive. Presenting my collection of gas pump and pickup truck photos to Countryman as a book idea then emerged.

With one look at the images, Kermit Hummel, editorial director, flashed a big smile and we were off and running—not driving—with *Out of Gas*.

Thank you to all at Countryman for your hard work and enthusiasm.

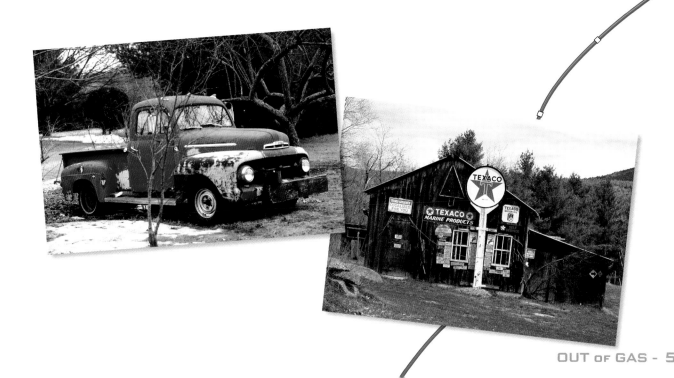

HAVING PHOTOGRAPHED ON LOCATION for numerous advertising and editorial clients, my travels have been vast. Almost three decades ago, while photographing rodeos throughout the Midwest, an old pickup truck abandoned on a prairie suddenly caught my eye. Vines and leaves engulfed it inside and out (page 46). What a shot.

During the same trip, I stumbled upon two more pickups in similar settings, and so a collection of photographs was born. During a roughly twenty-eight-year period, I photographed the old pickups in this book throughout the United States.

Fifteen years ago, while in New Mexico, I came upon an Indian trading post. Two round red gas pumps were fixed in front, with a sign hanging between them: one side read OPEN, the other CLOSED. Suddenly another photographic theme was born, one that coincided perfectly with the pickups. I've photographed only gas pumps that are no longer functional and that dispensed only leaded gasoline—a relic in itself.

I've found these pickups and old pumps in every corner of the country. One pickup with a deteriorating wooden roof (page 9) I found in Maui, Hawai'i. One gas pump (page 12) I found in Bradford, New Hampshire, just 20 minutes from my home. I've found them in fields, backyards, in front of homes, and of course, at gas stations.

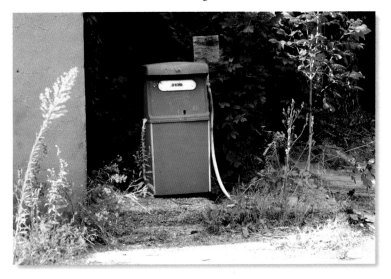

Today, with gasoline at record prices, we are all asking ourselves how and when our dependency on the pump and on the fossil fuels it dispenses will cease. Looking through the photos in this book, I wonder if I'll someday start a collection of photos of *unleaded* gasoline pumps, or if my collection of pickup photos will grow as the number of trucks on the road dwindles.

We'll see.

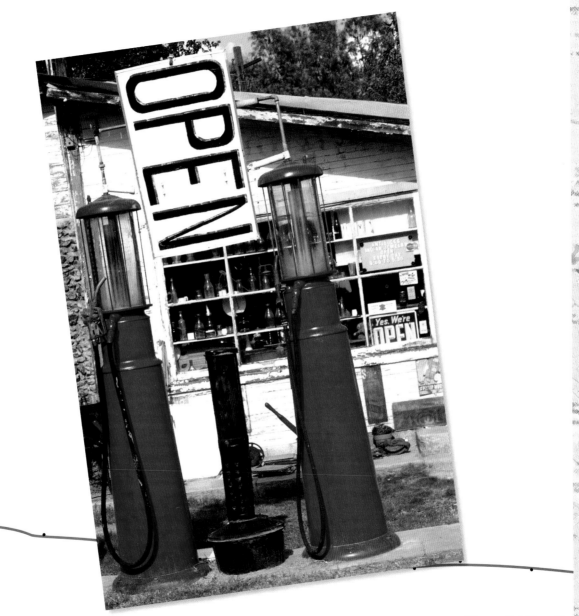

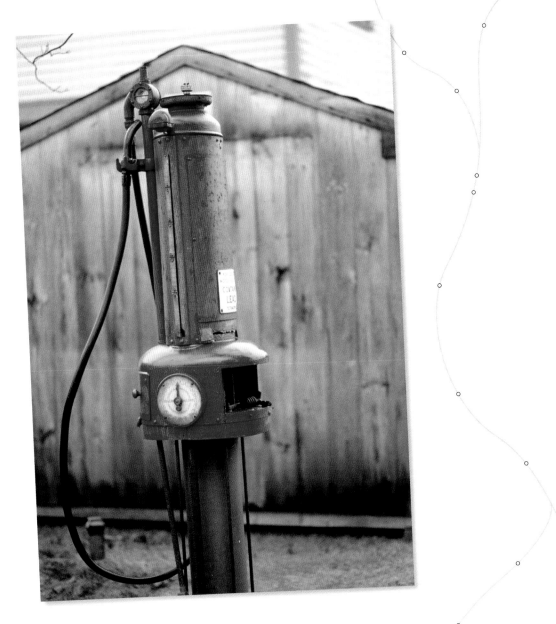

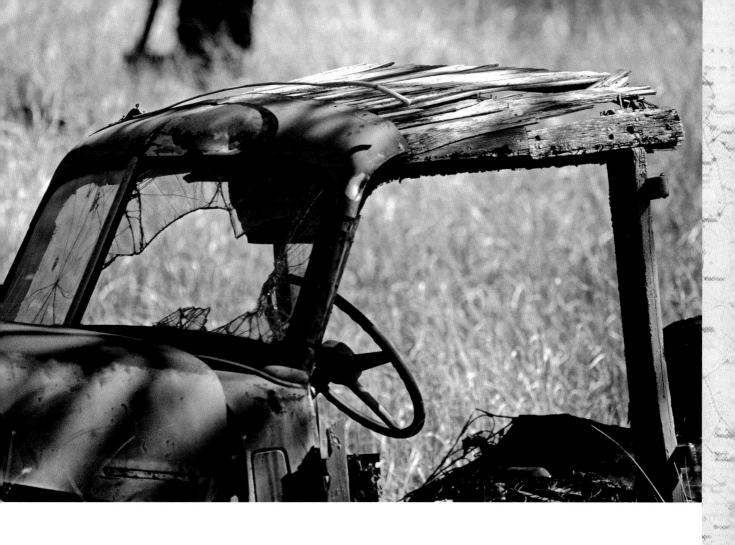

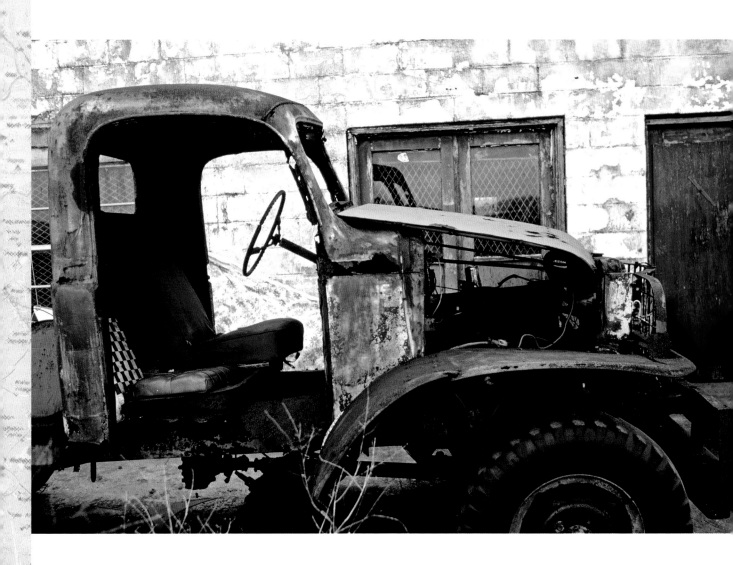

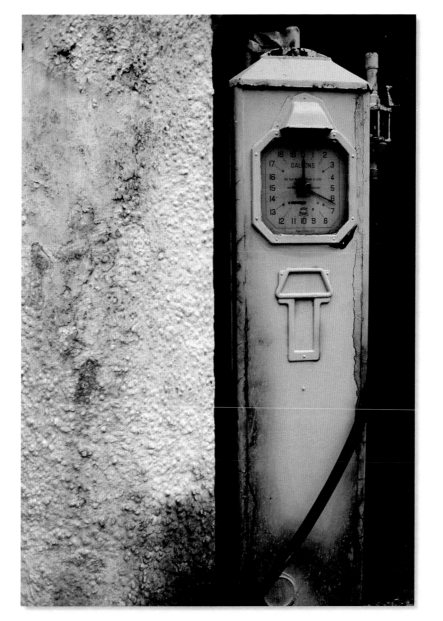

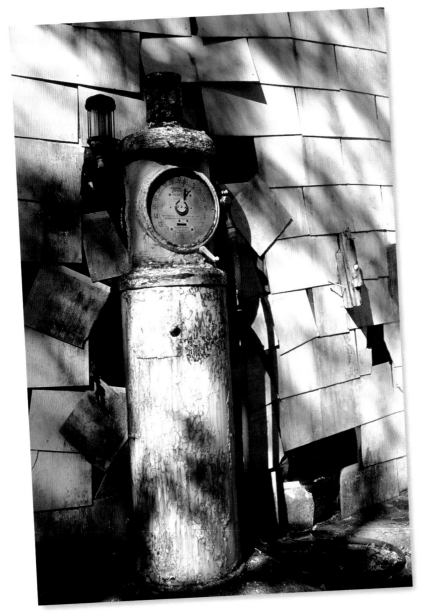

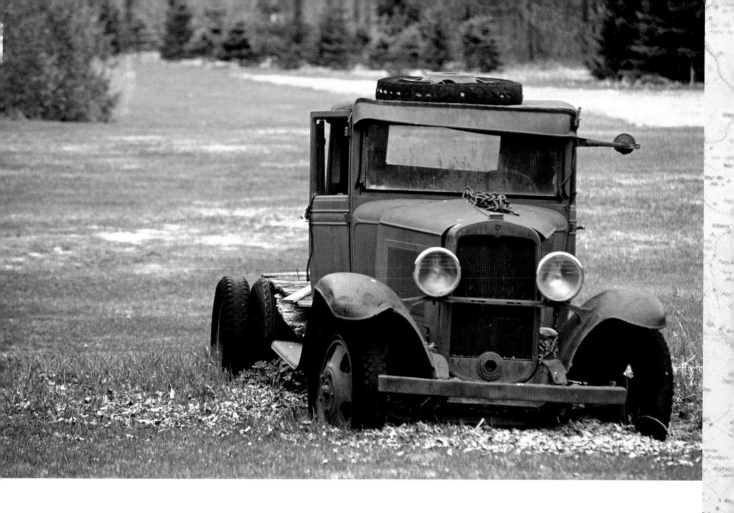

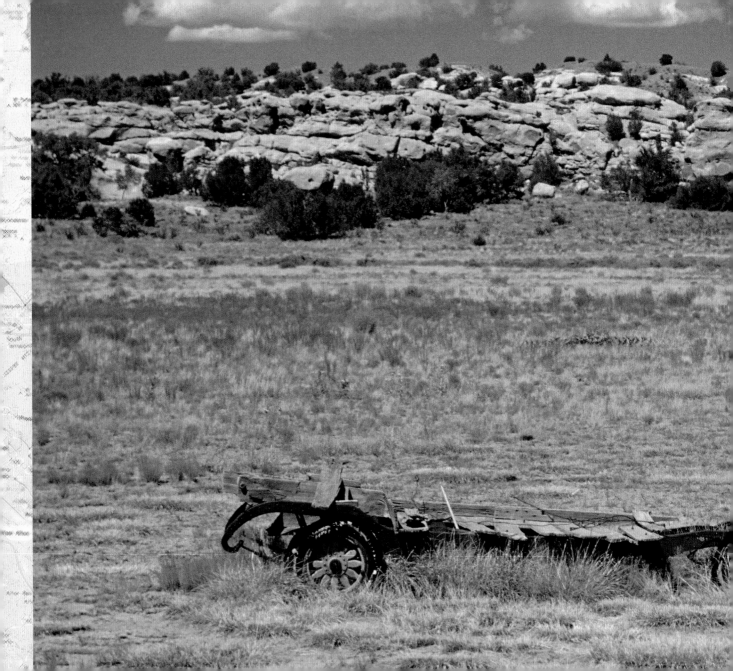

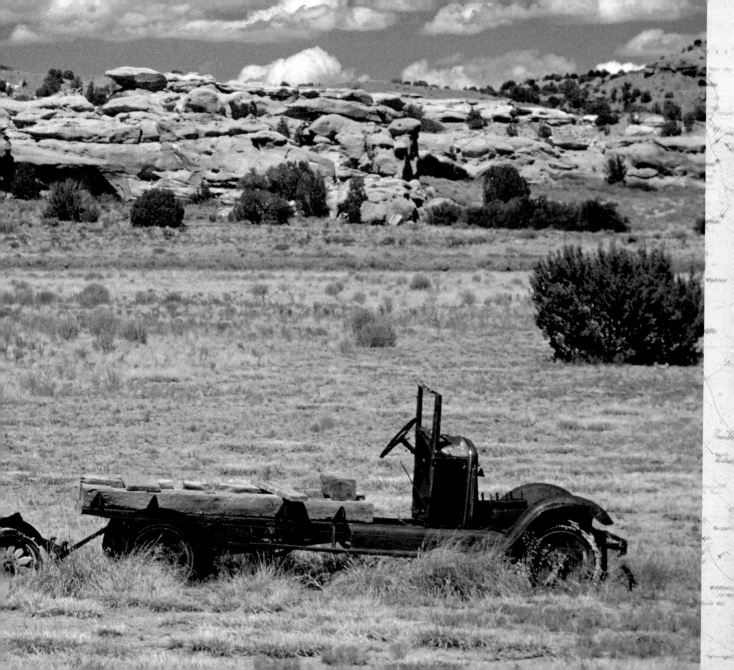

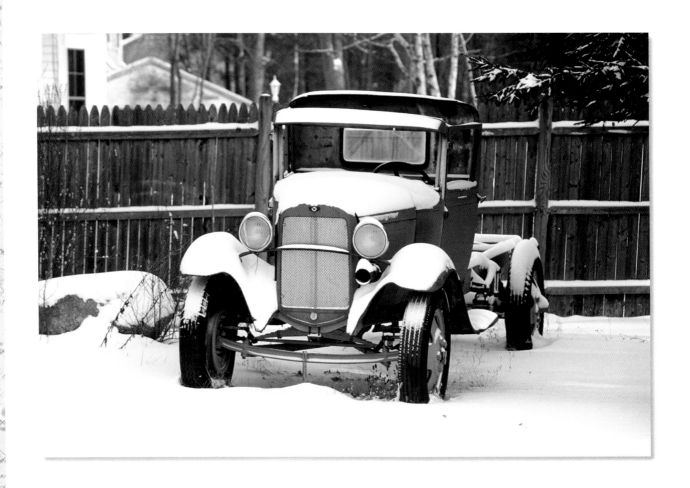

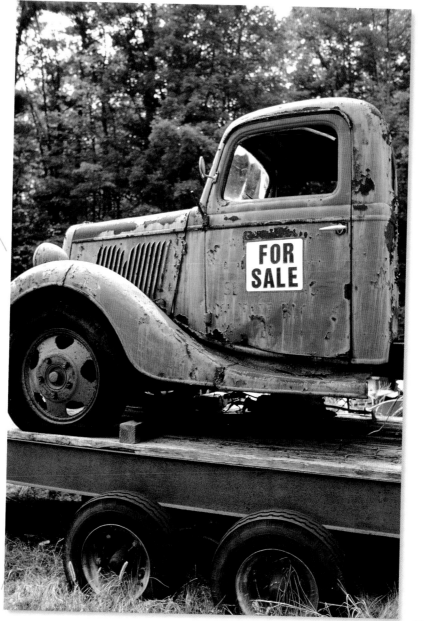

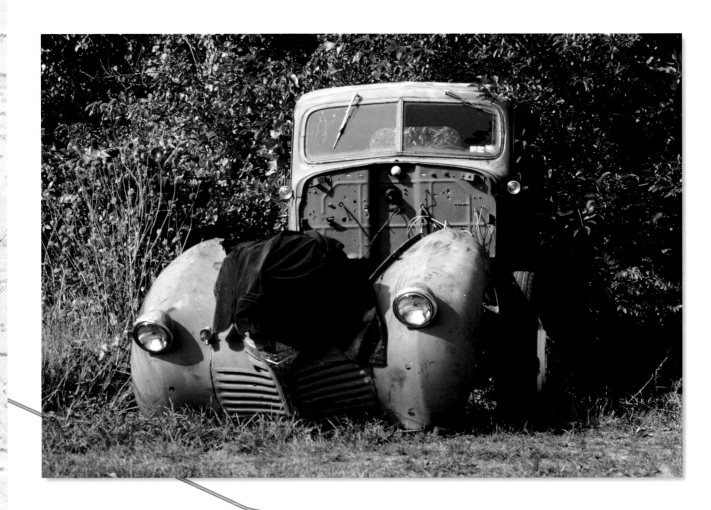

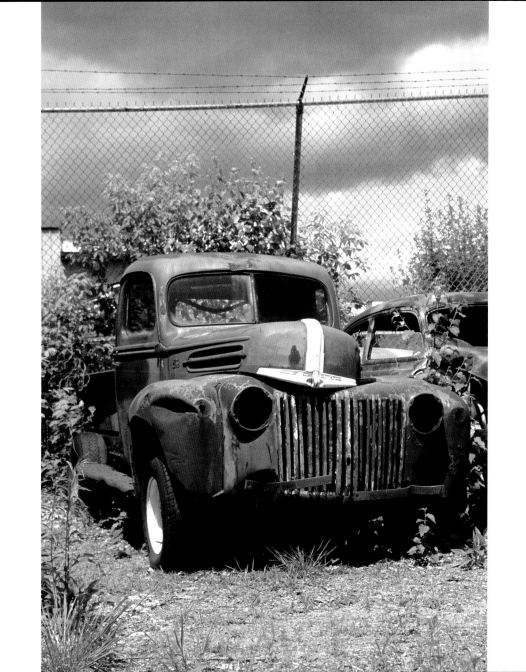

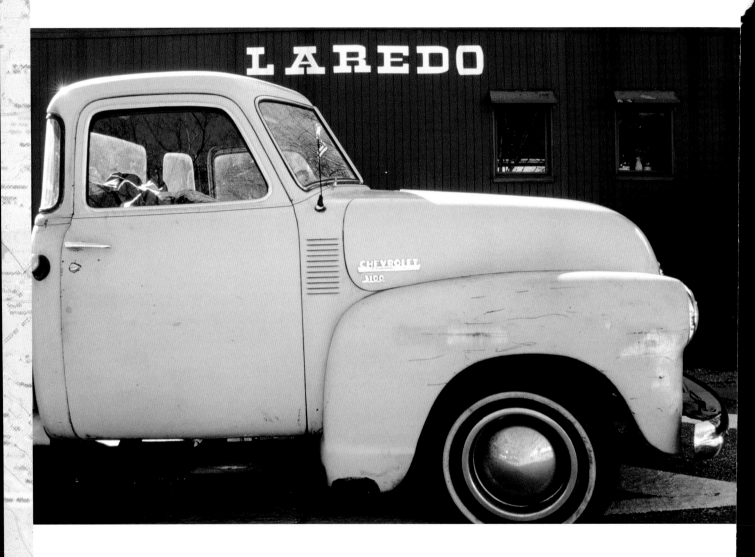

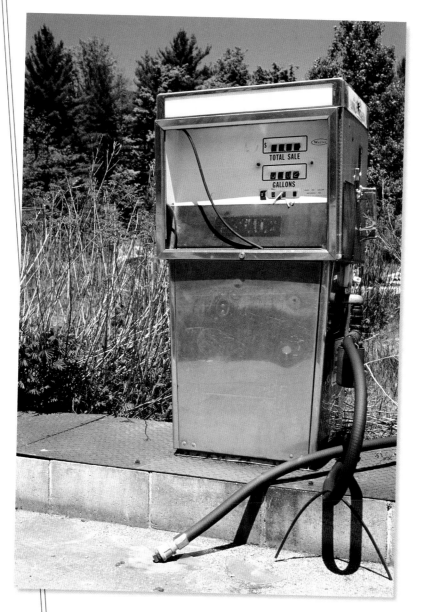

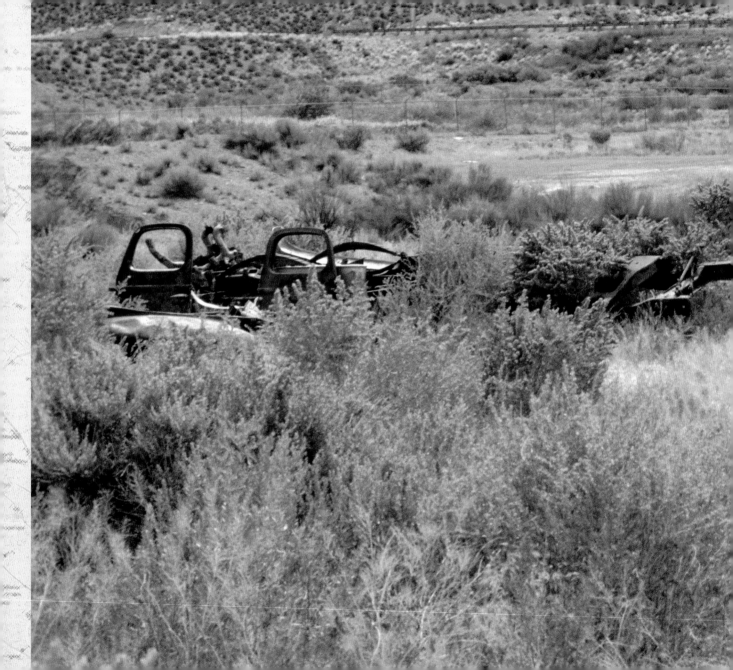

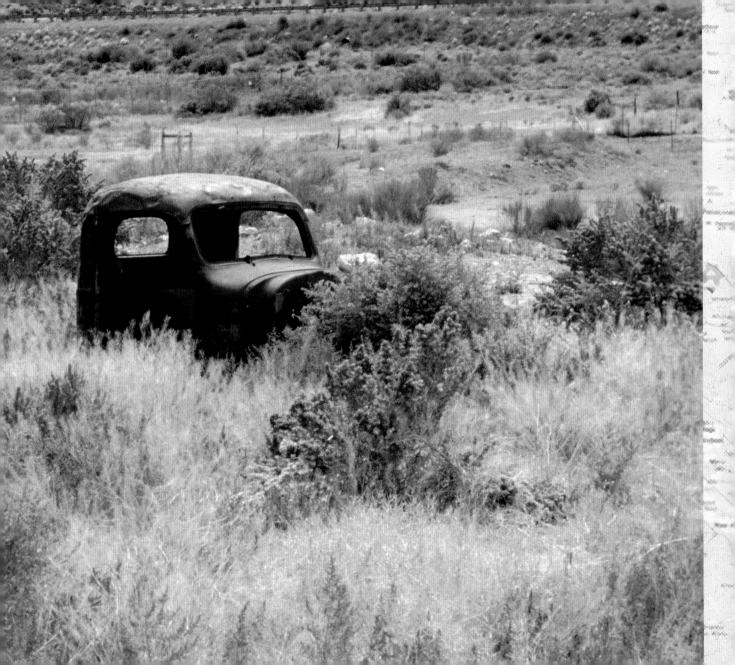

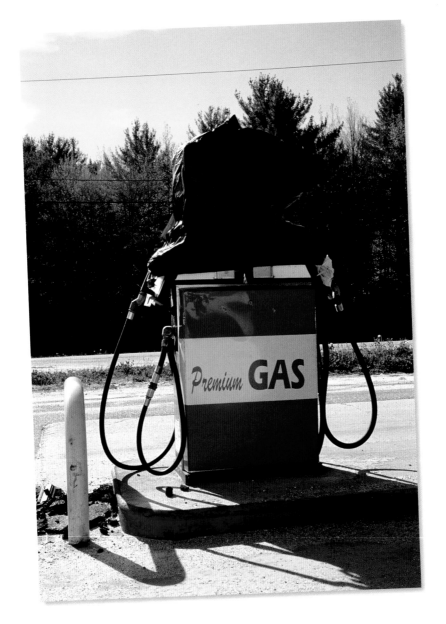

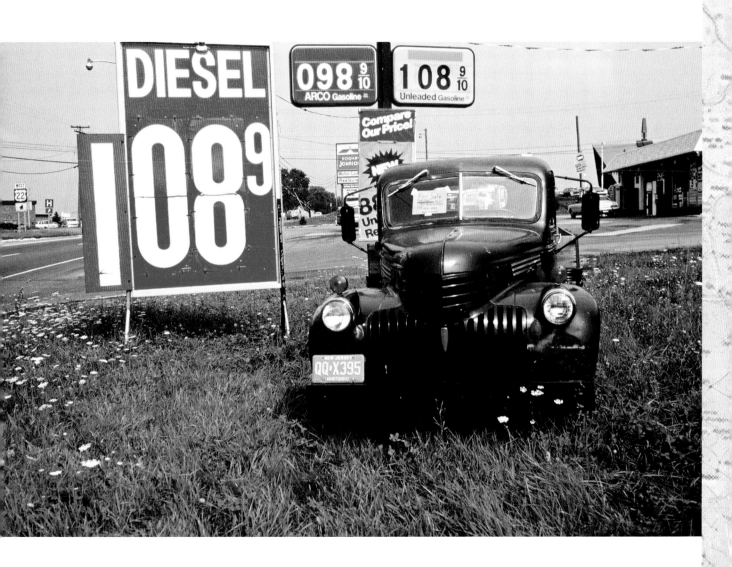

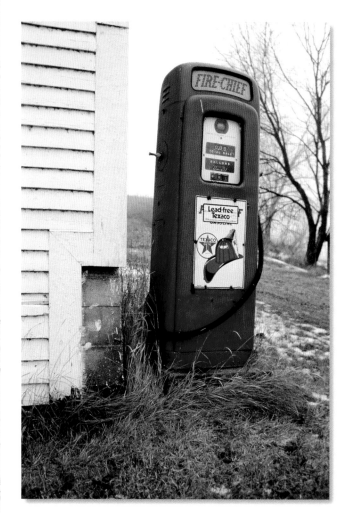
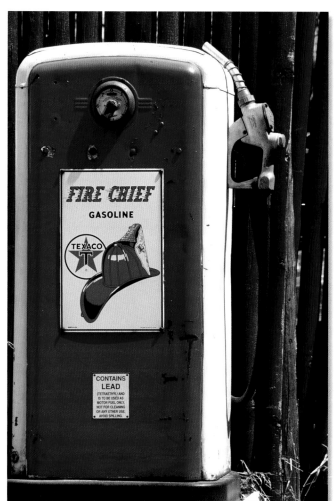

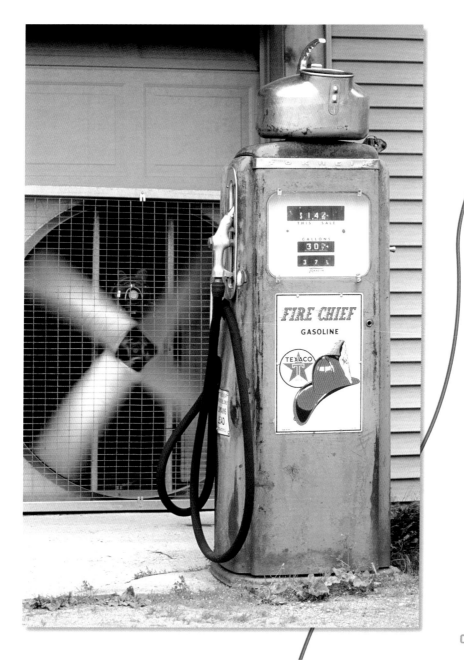

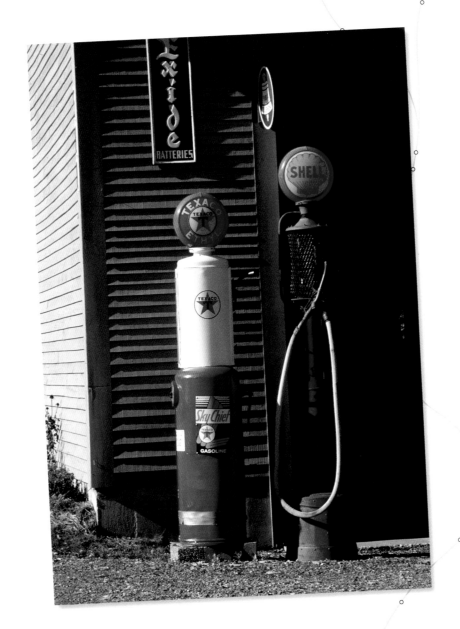

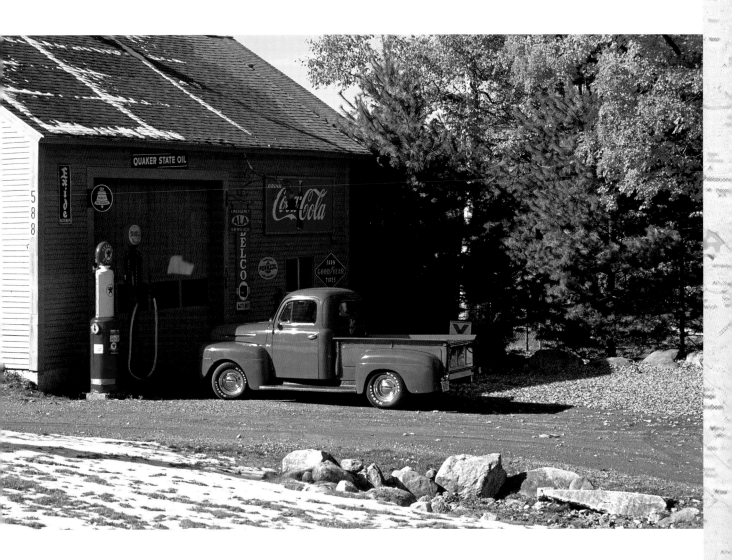

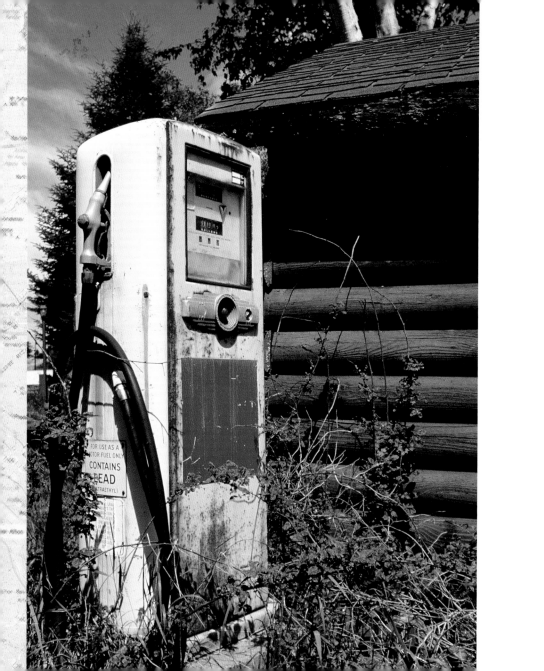

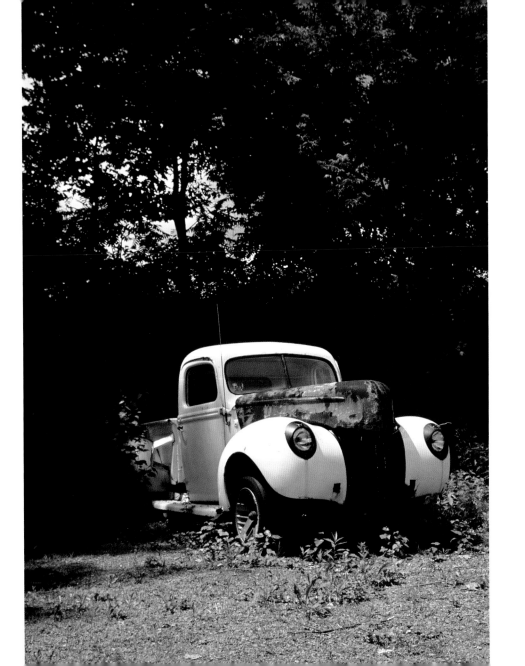

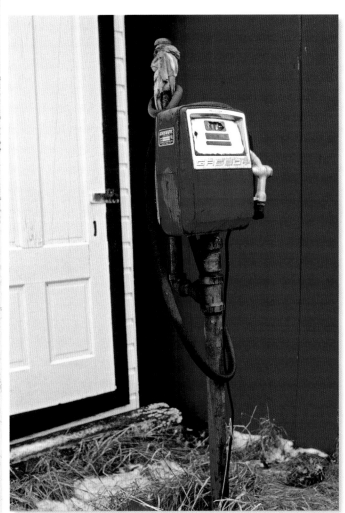
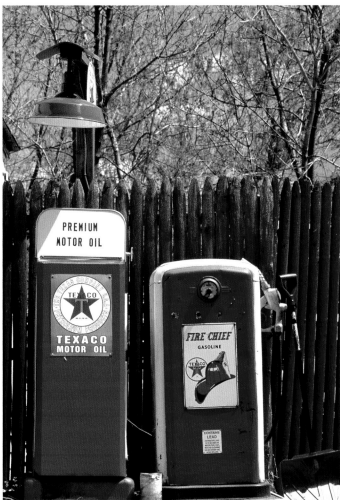

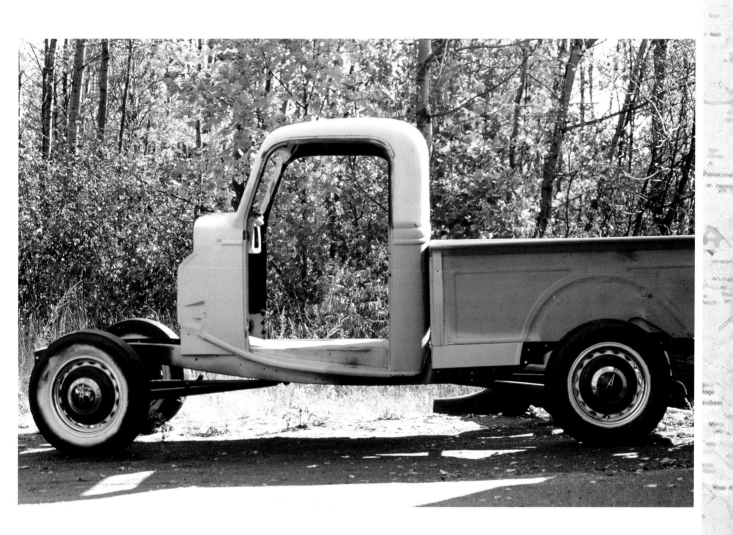

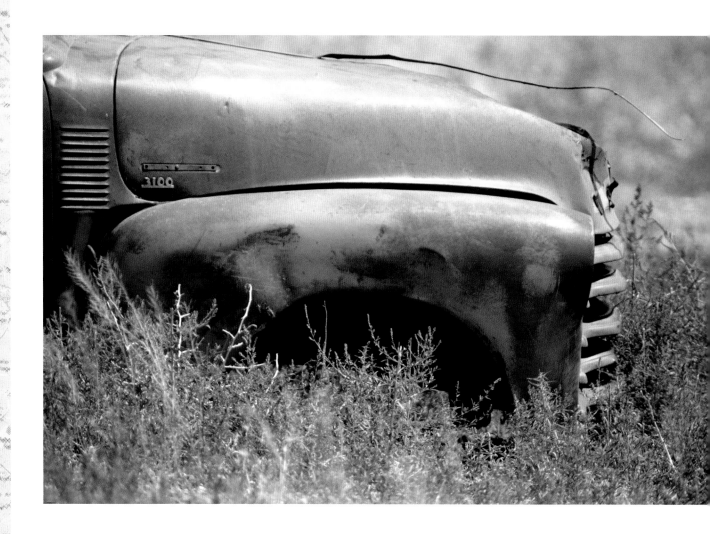

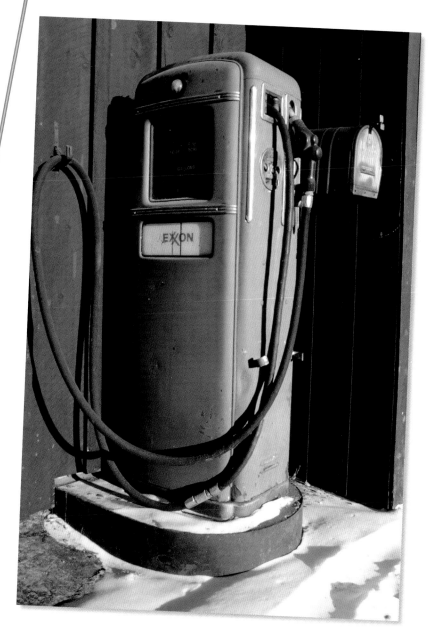

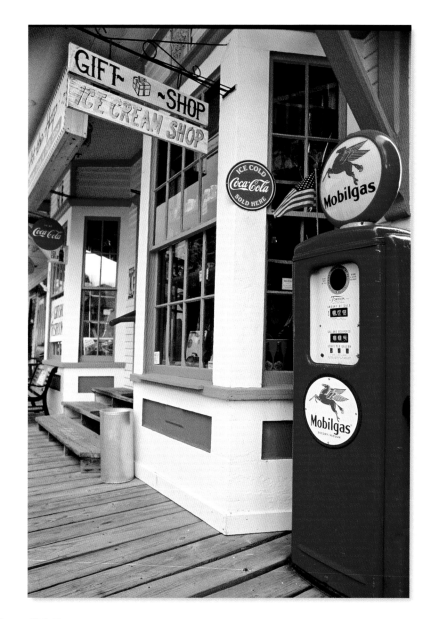

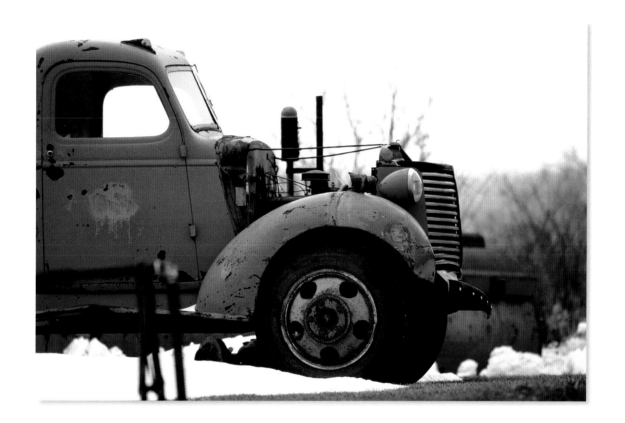

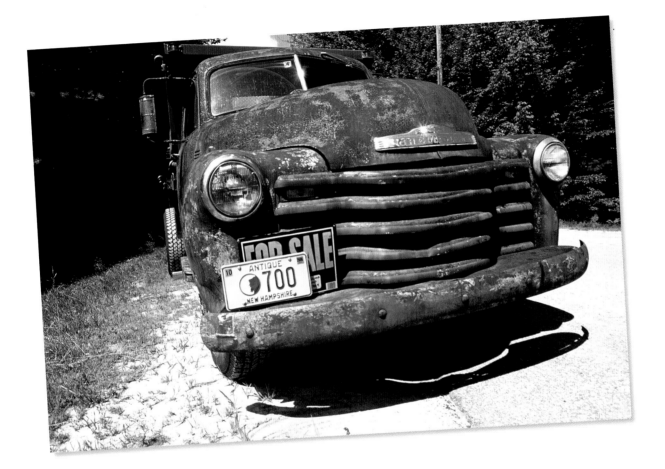

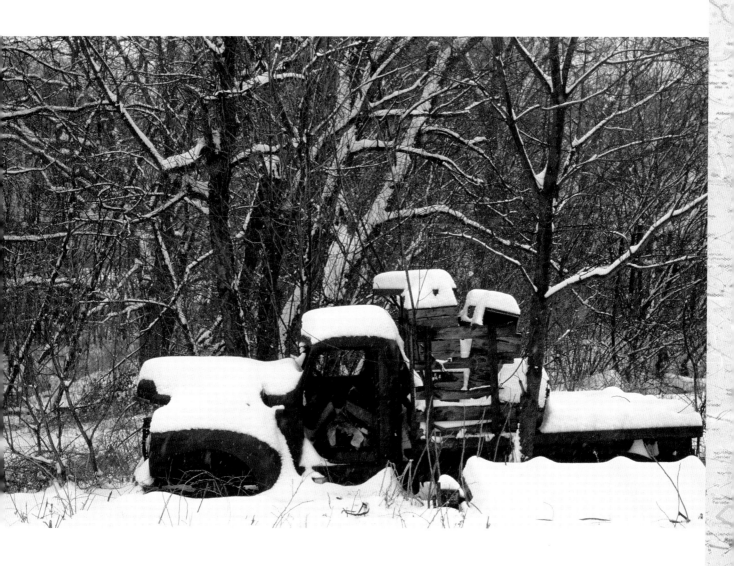

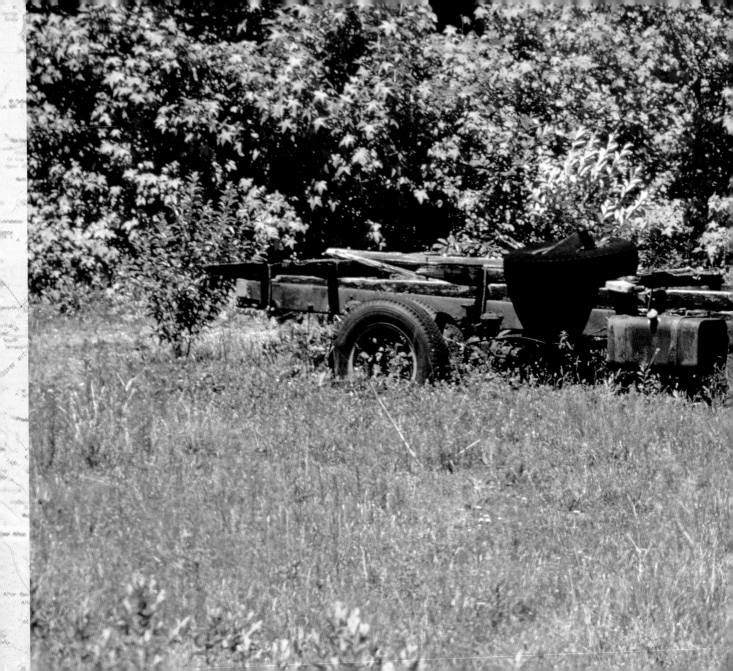

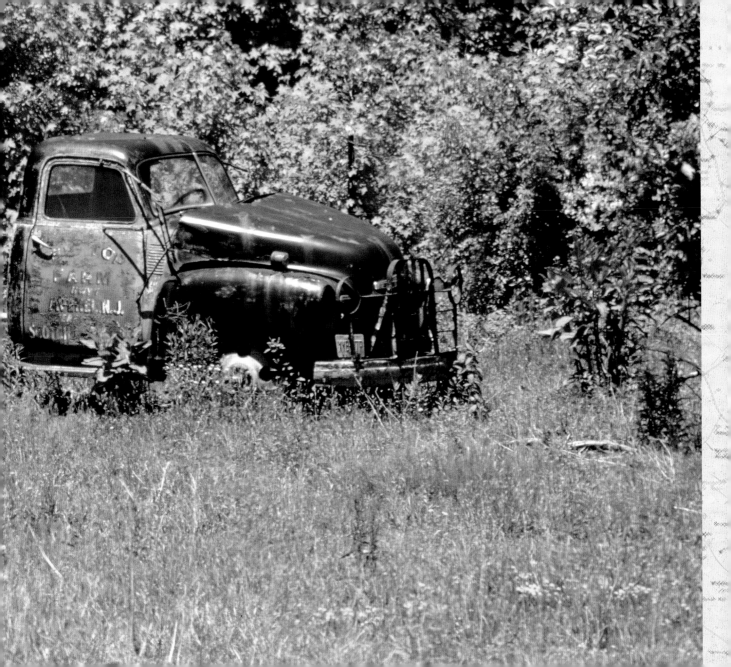

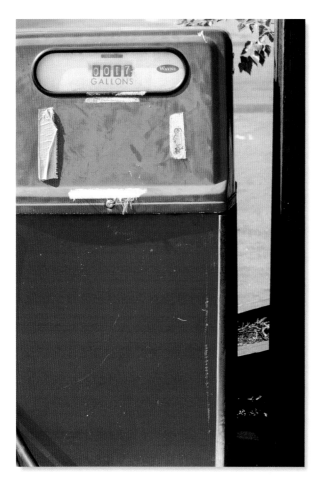

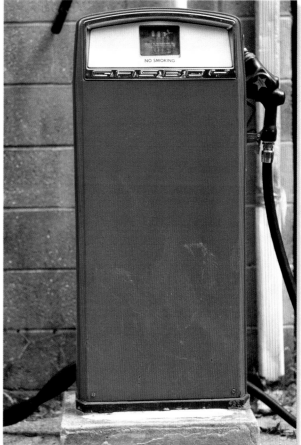

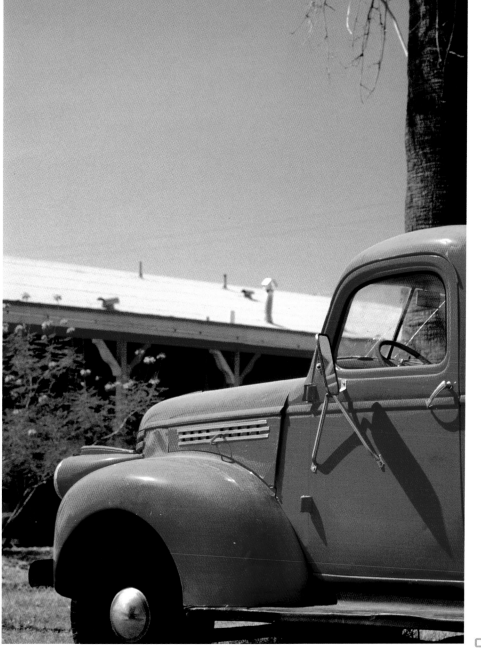

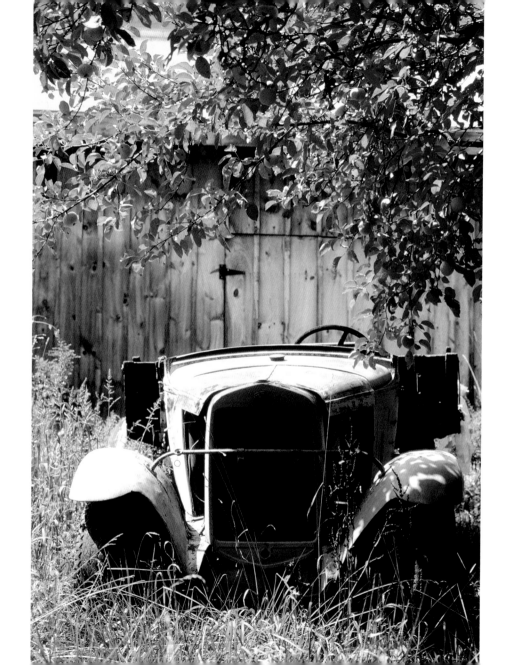

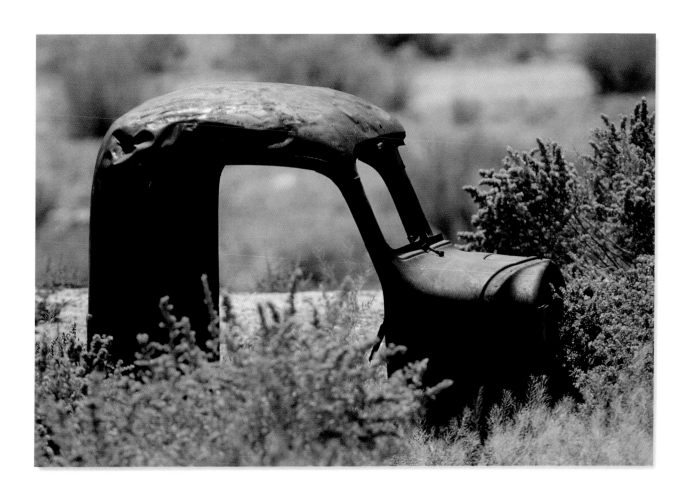

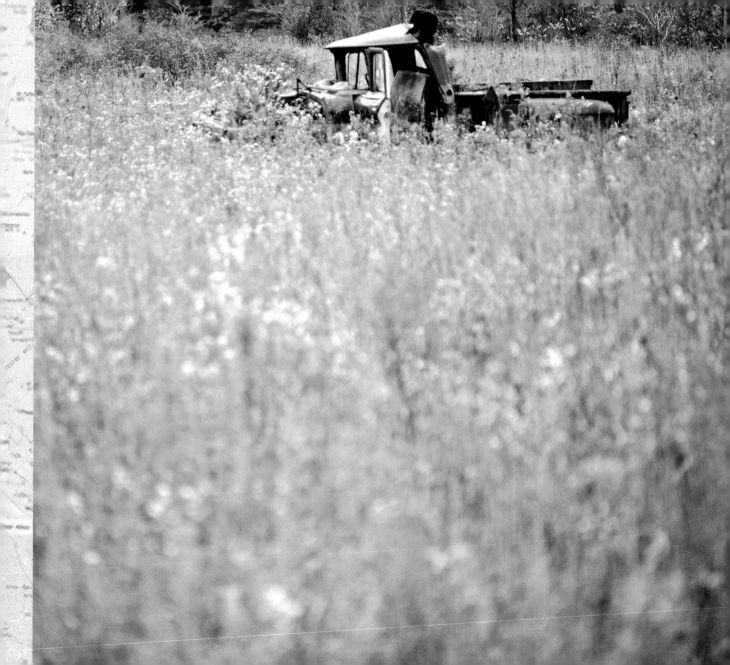

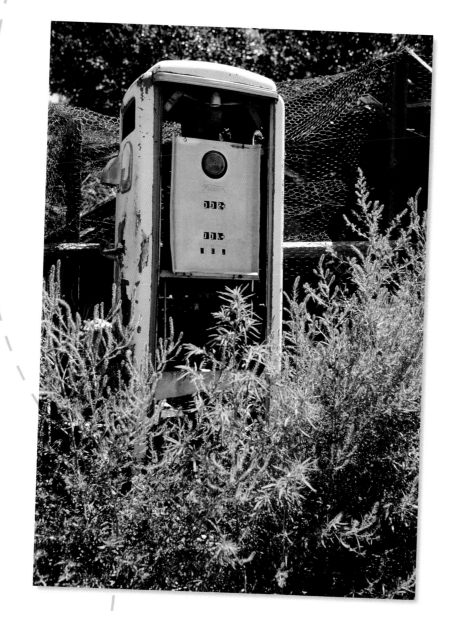

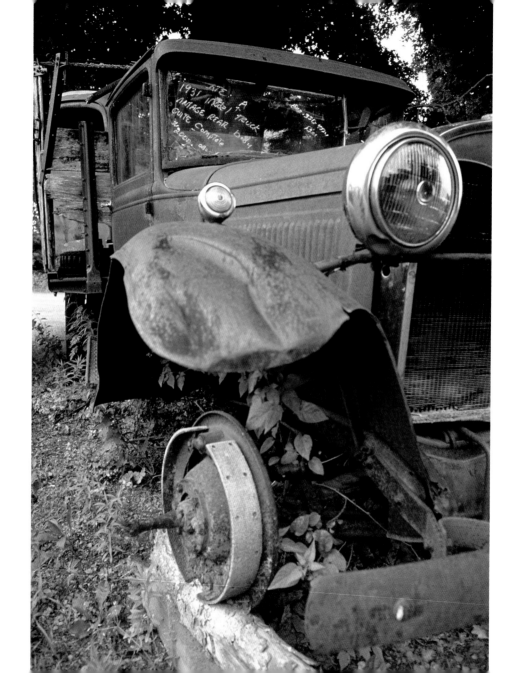

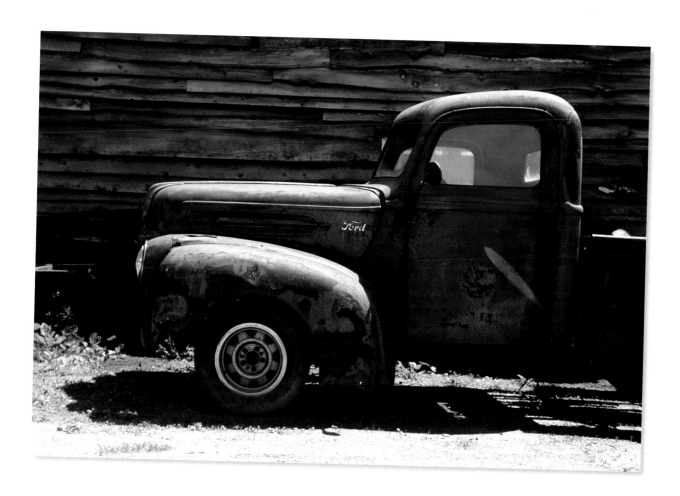

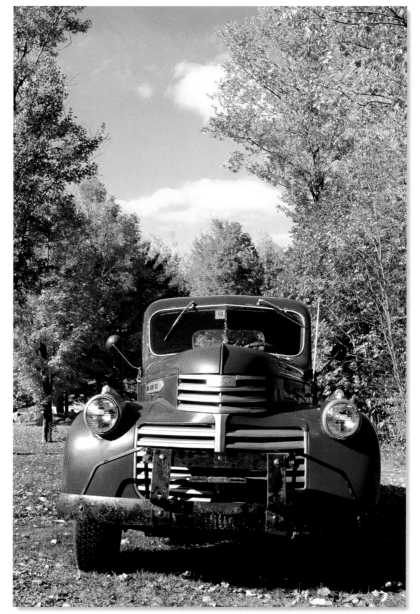

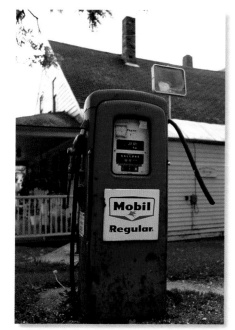
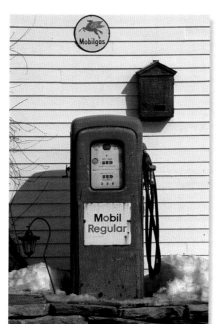
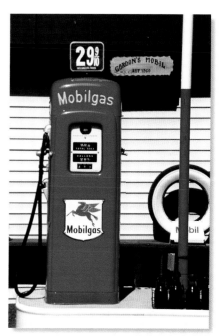

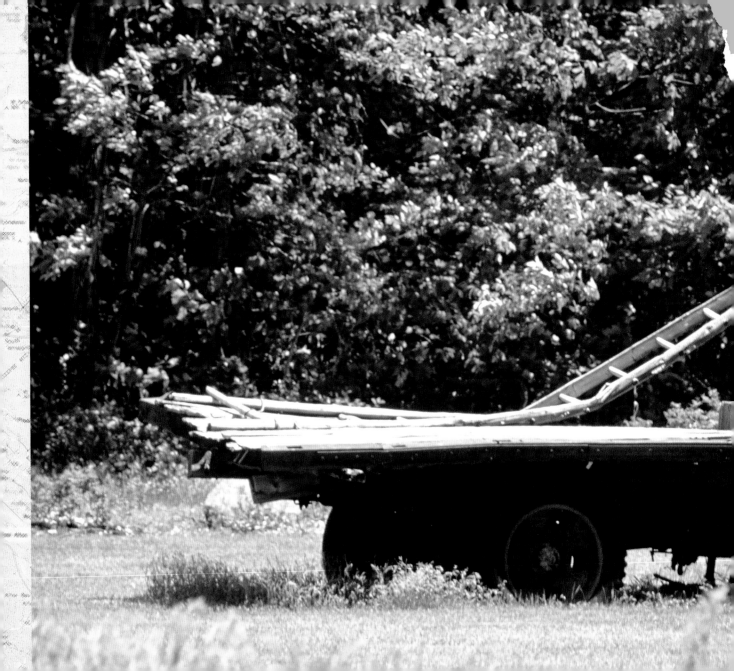

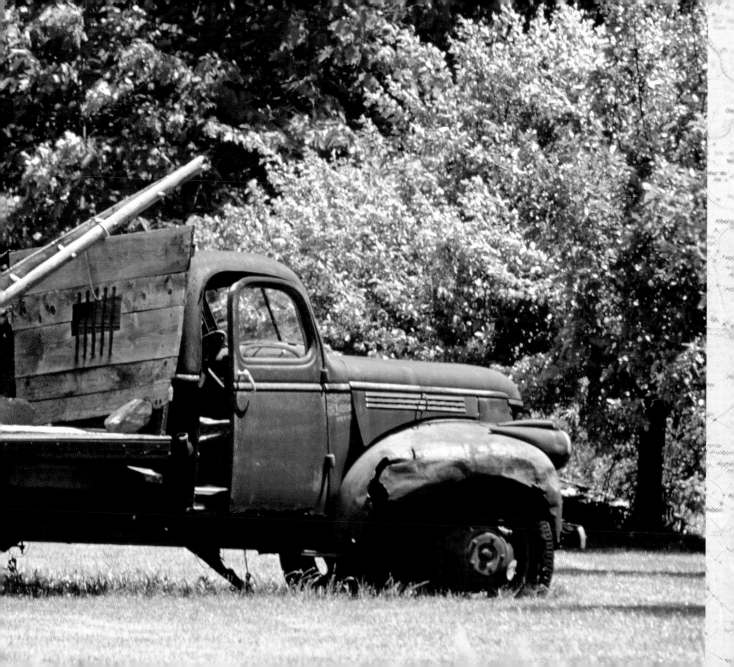

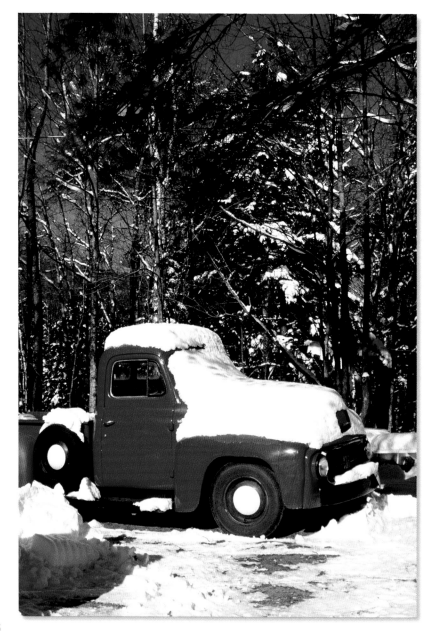

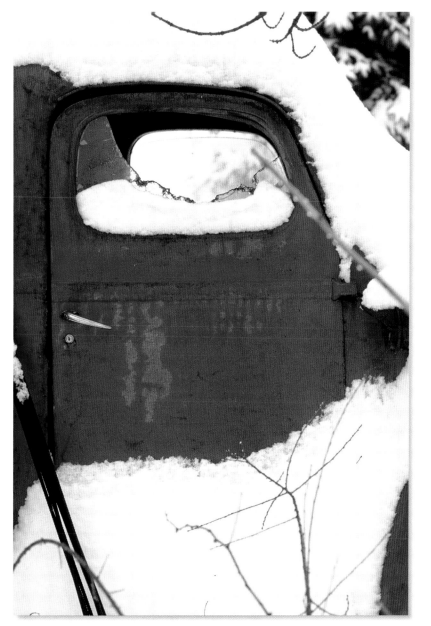

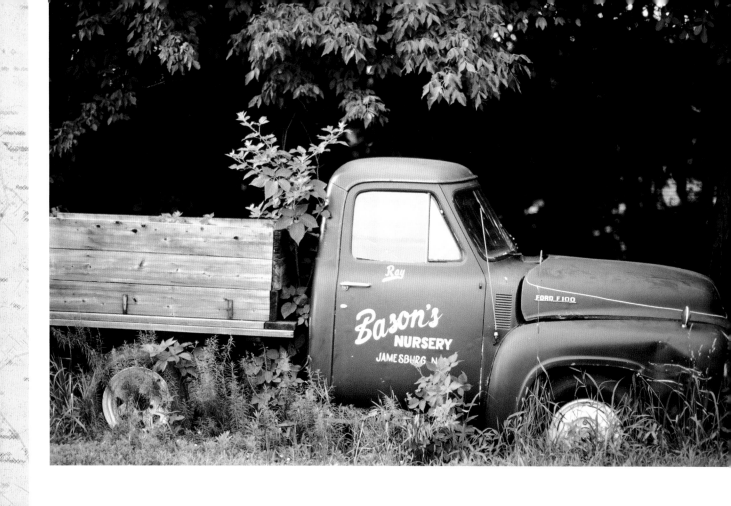

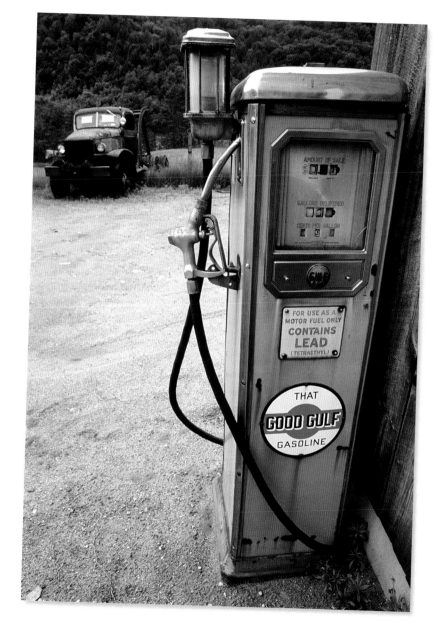

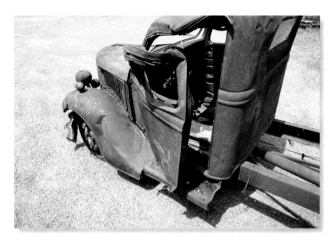

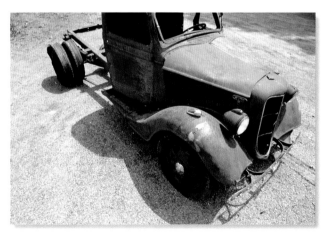

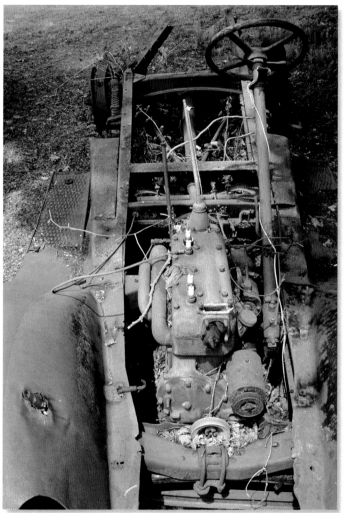

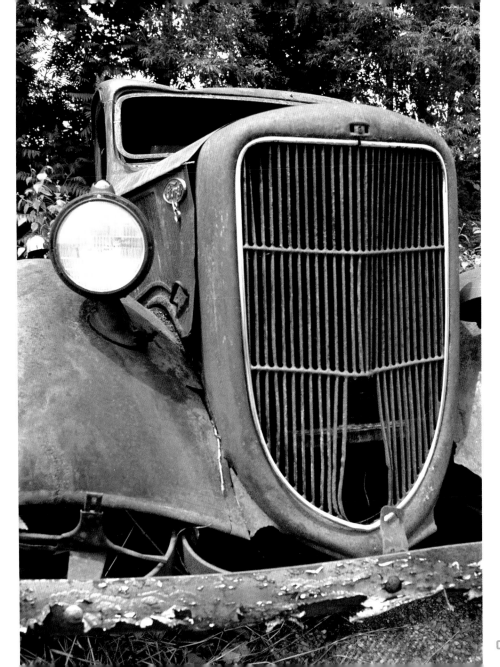

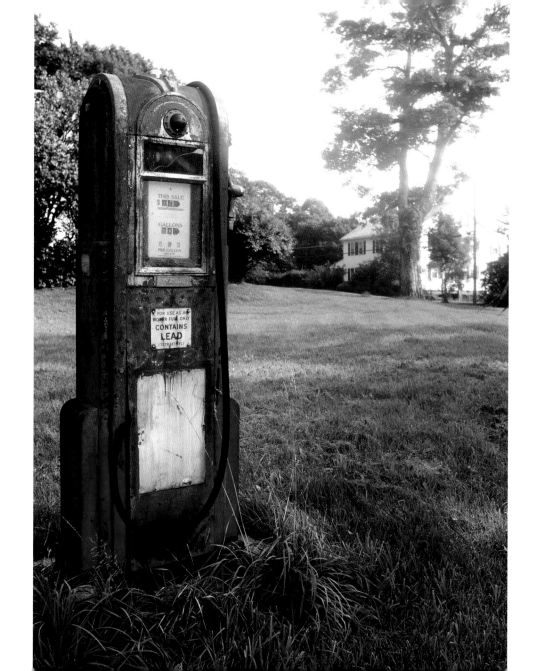

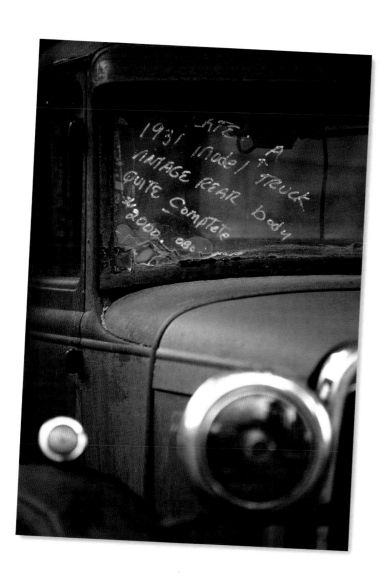

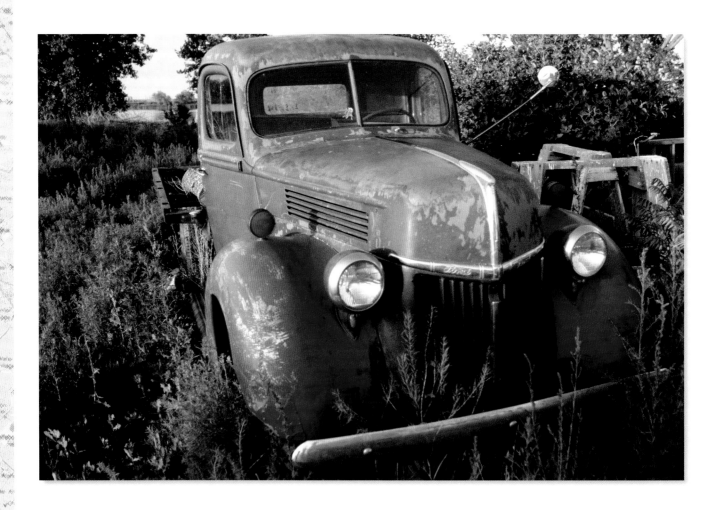

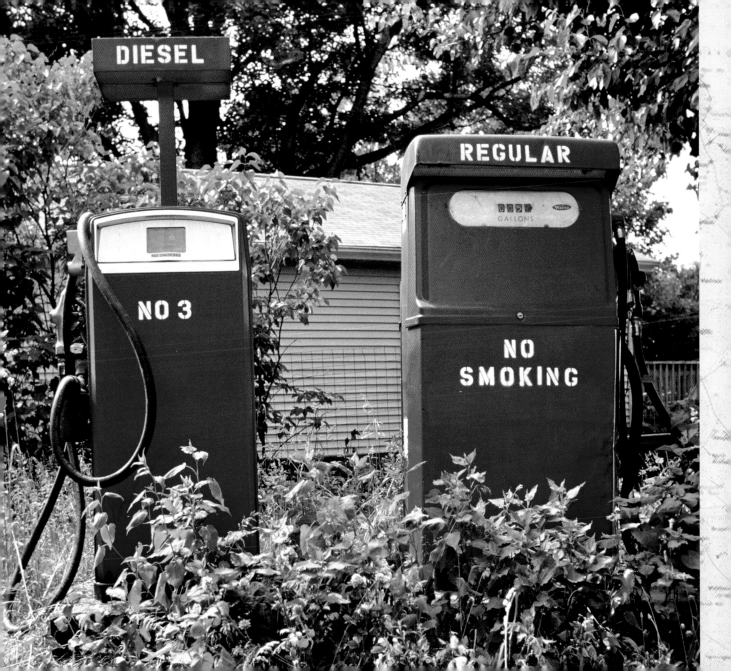

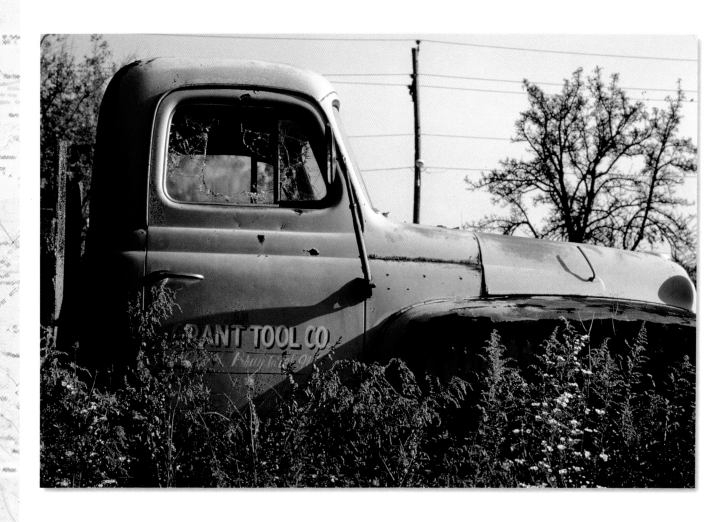

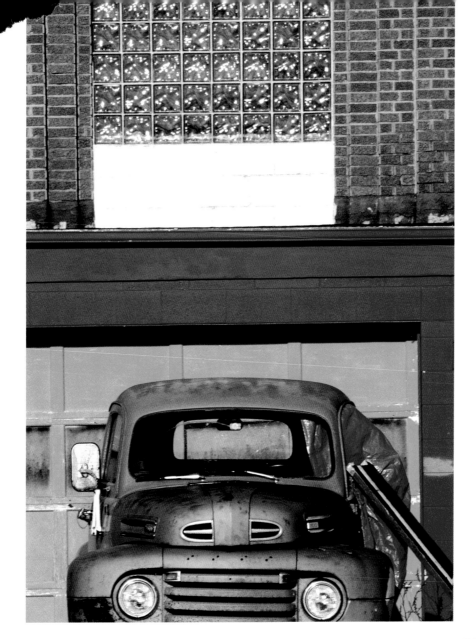

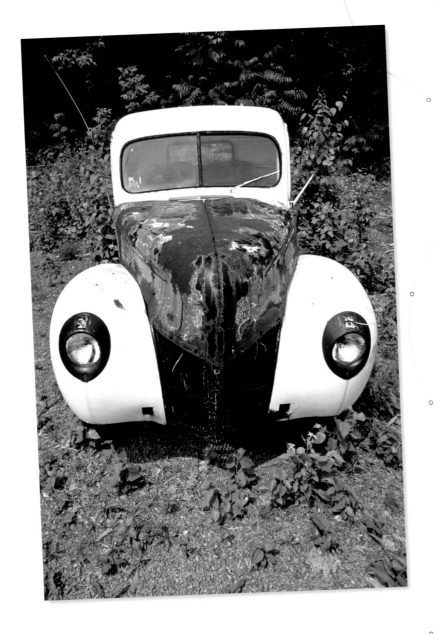

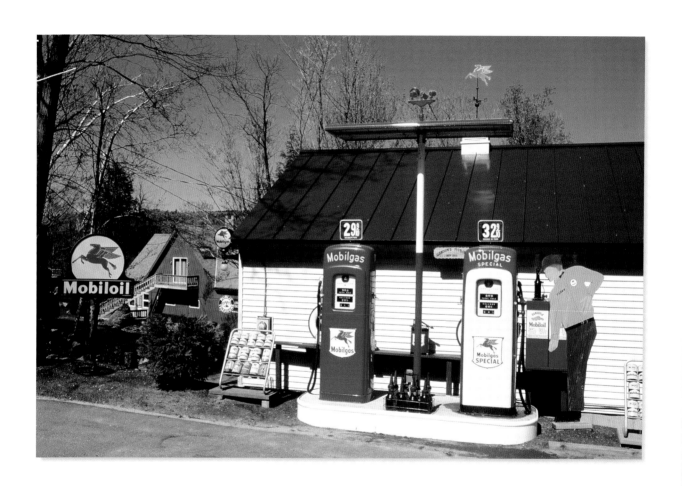

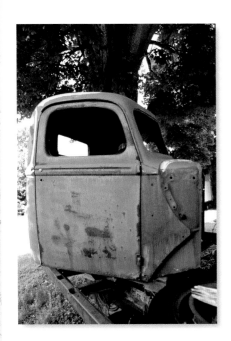

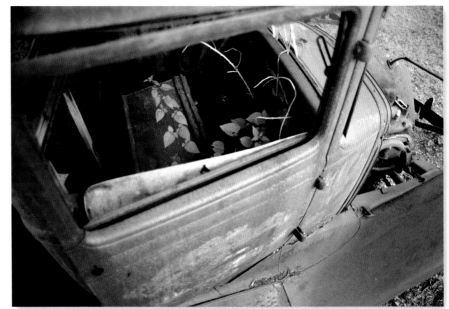

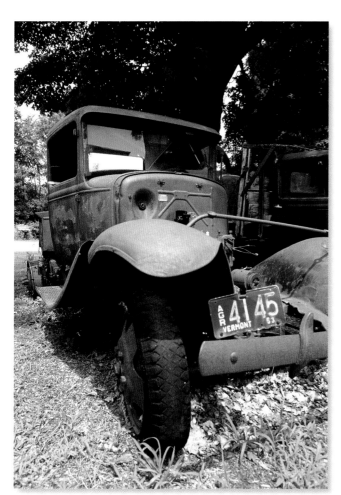

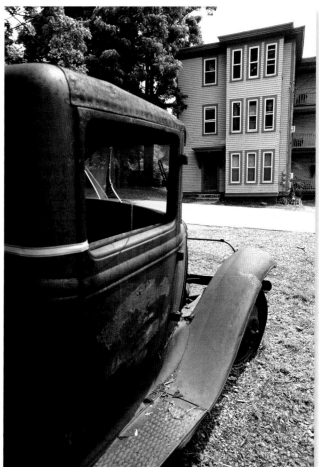

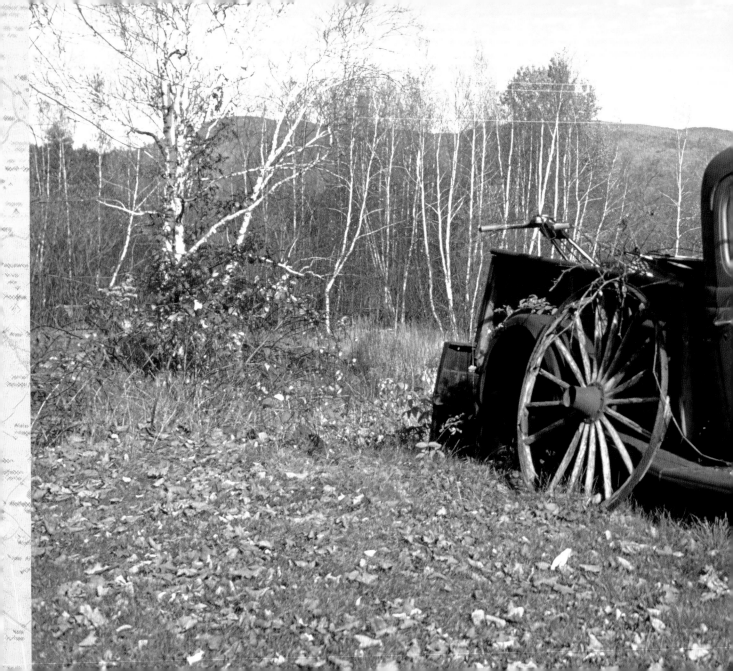

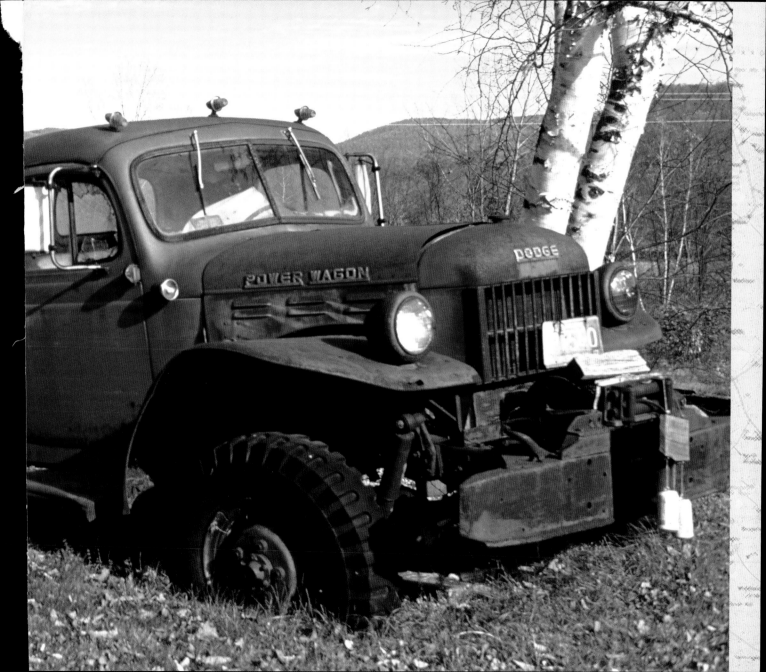

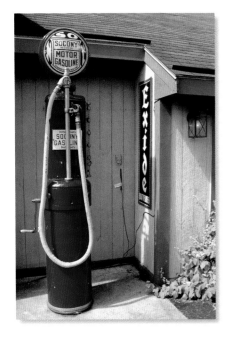 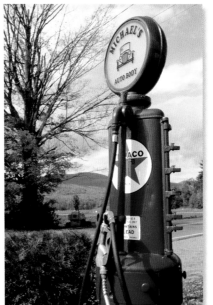 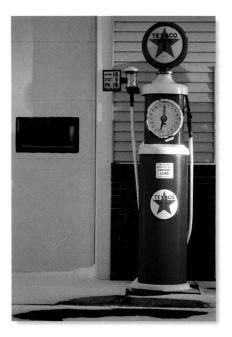

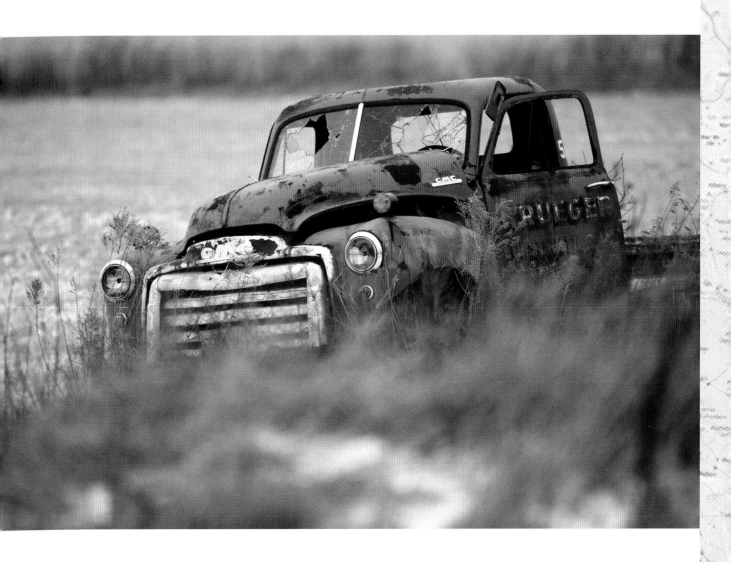

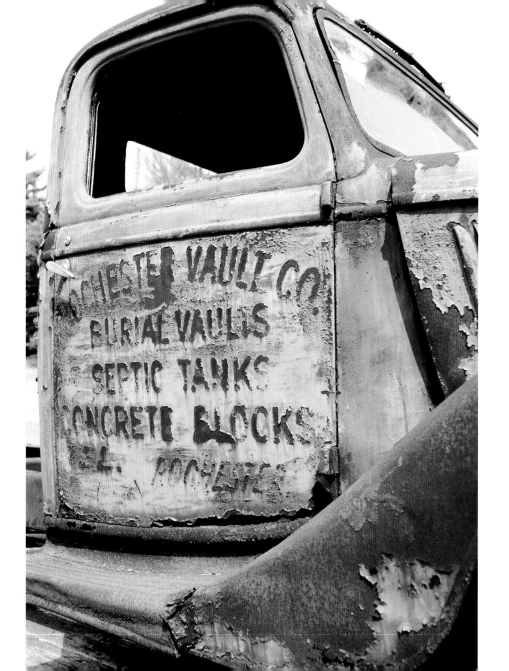

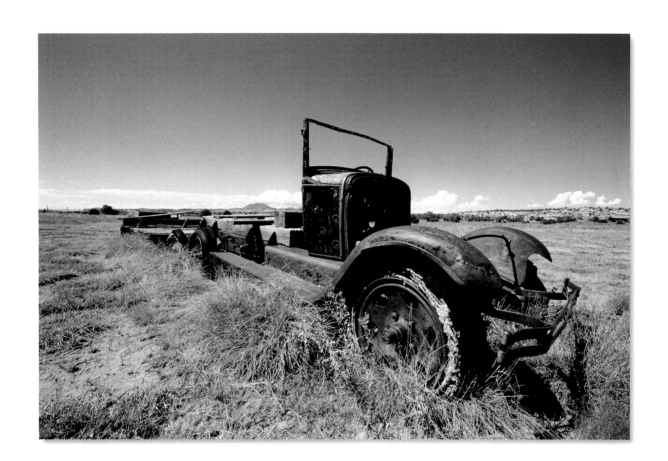

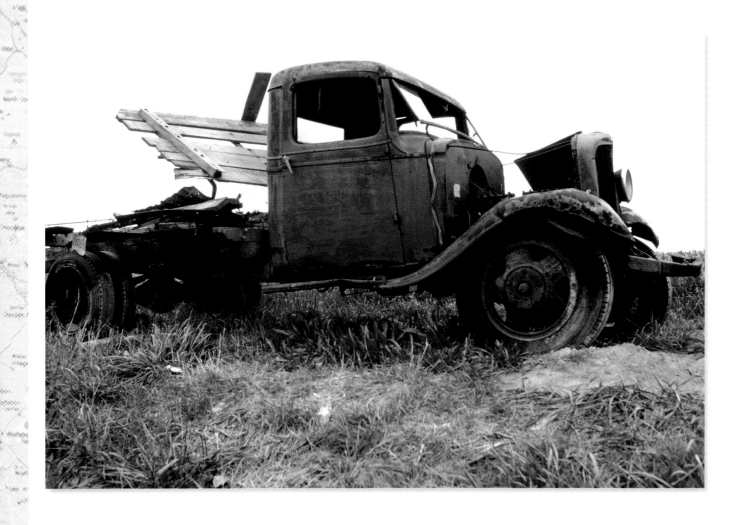

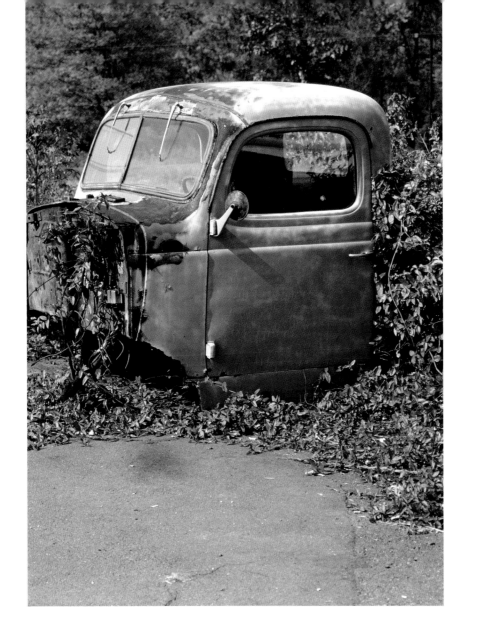

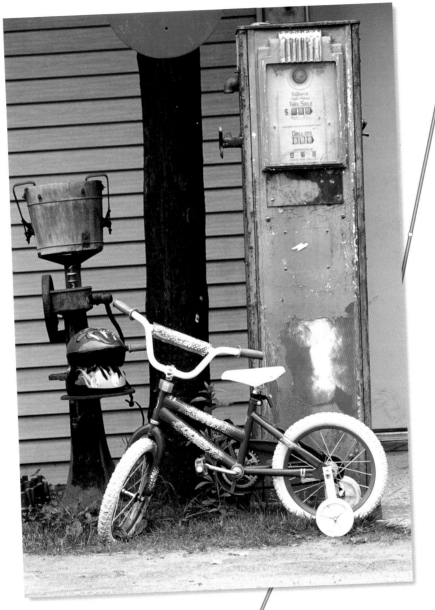

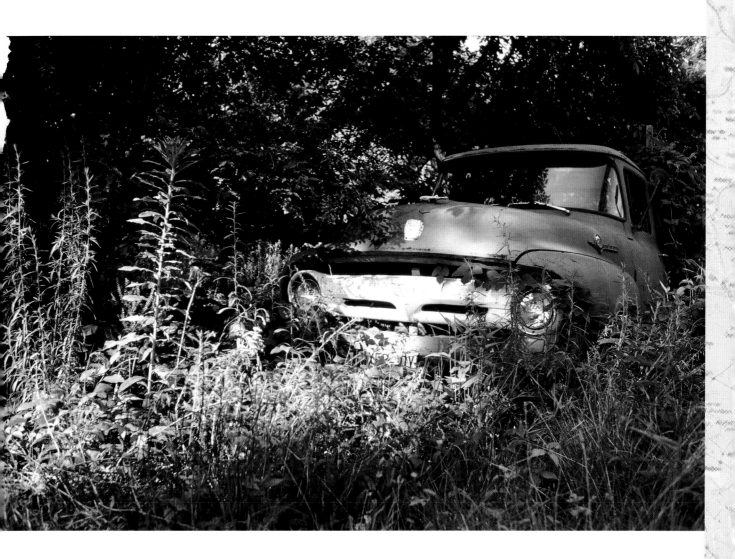

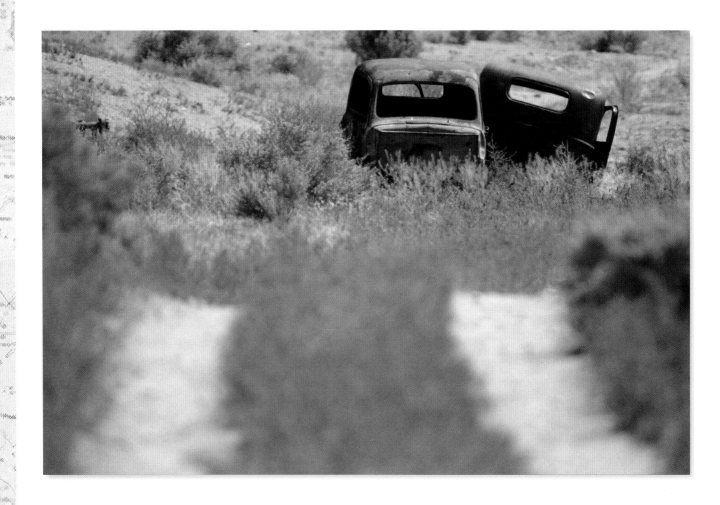

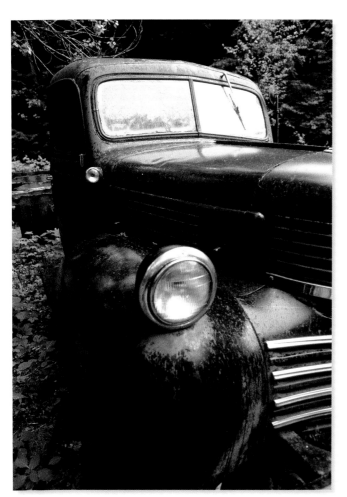

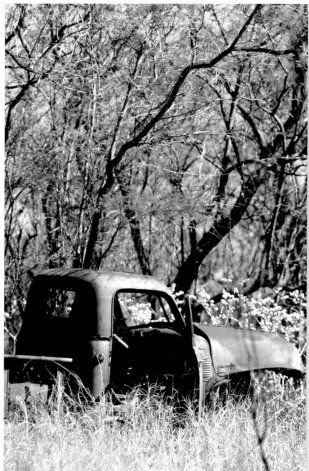

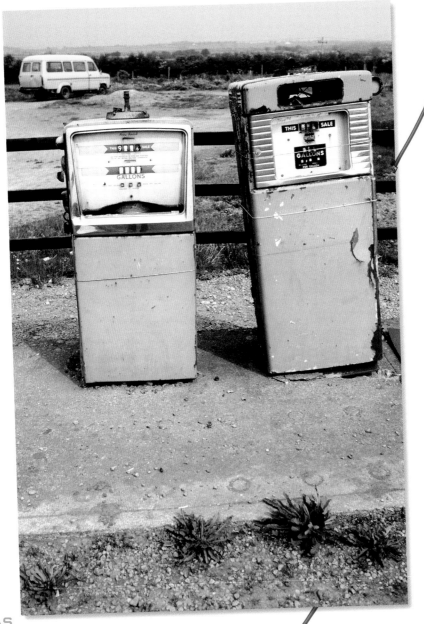

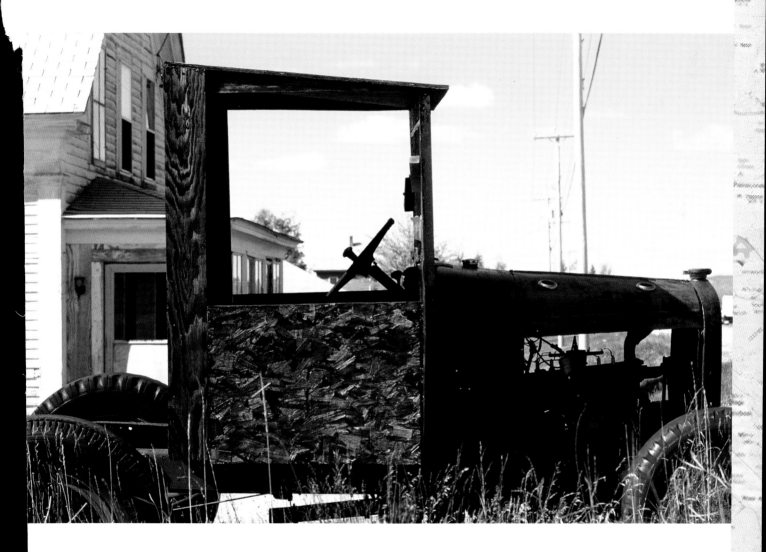

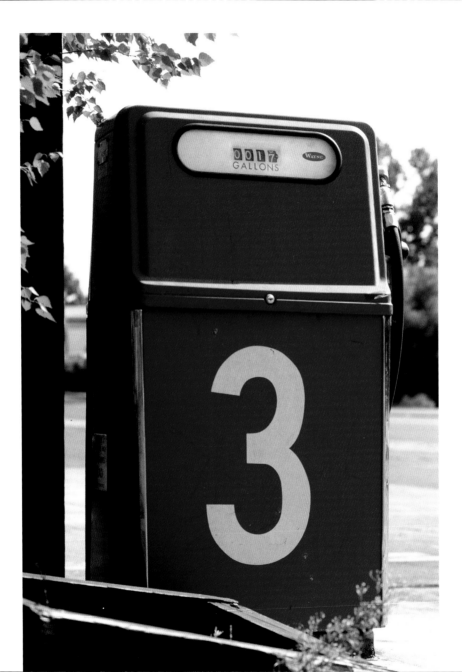

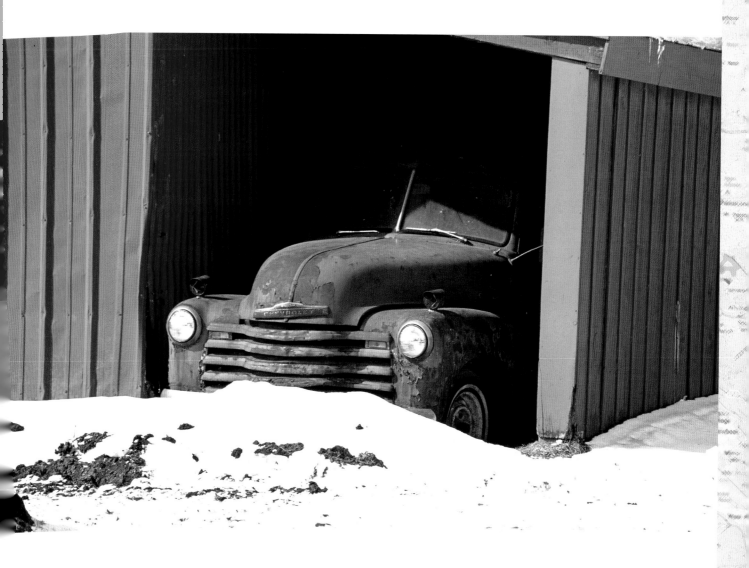

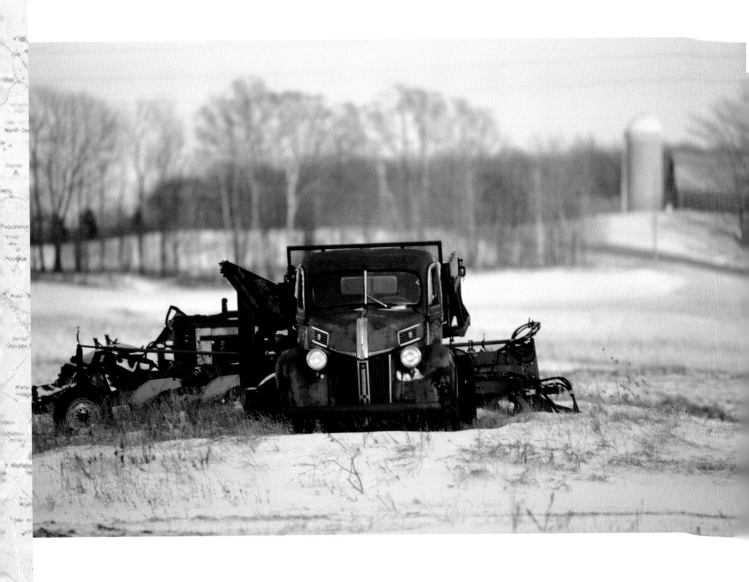

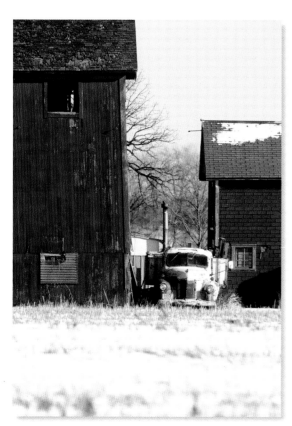

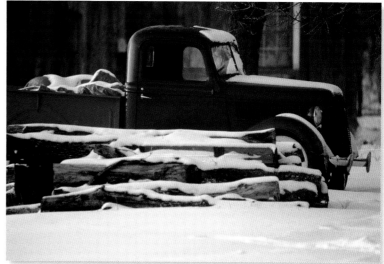

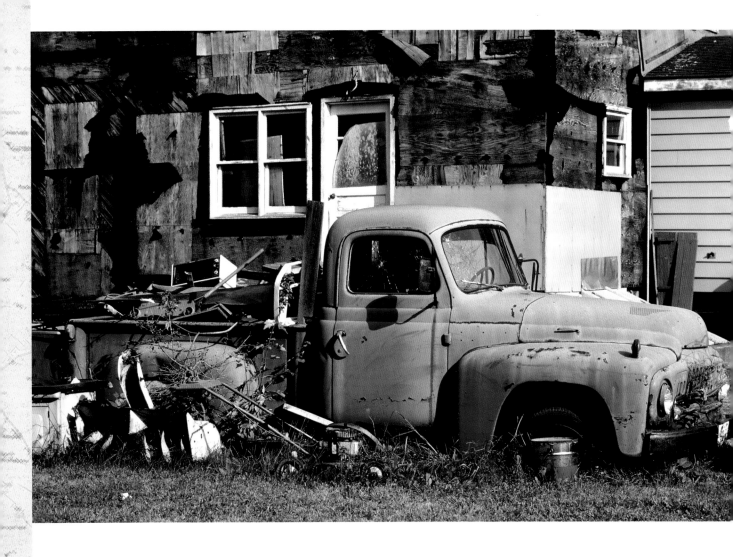

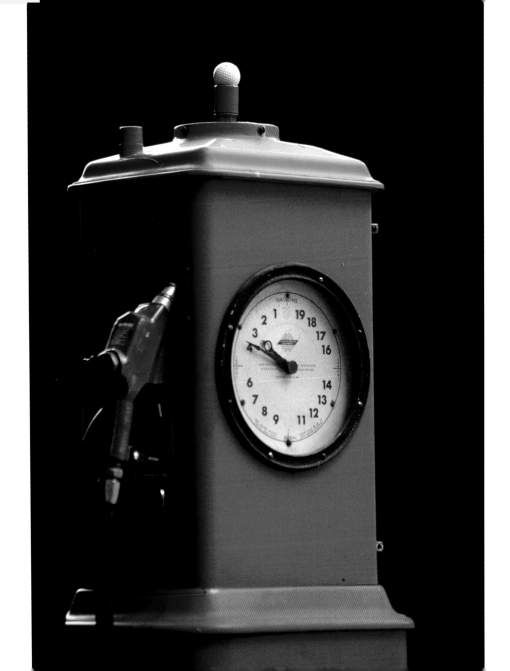

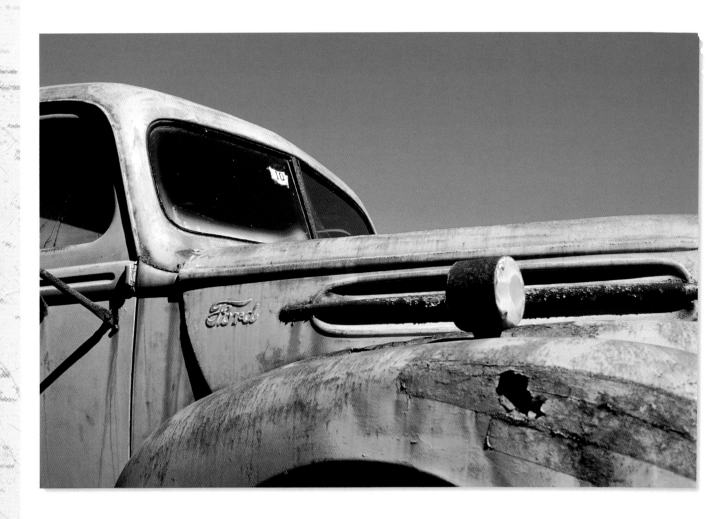

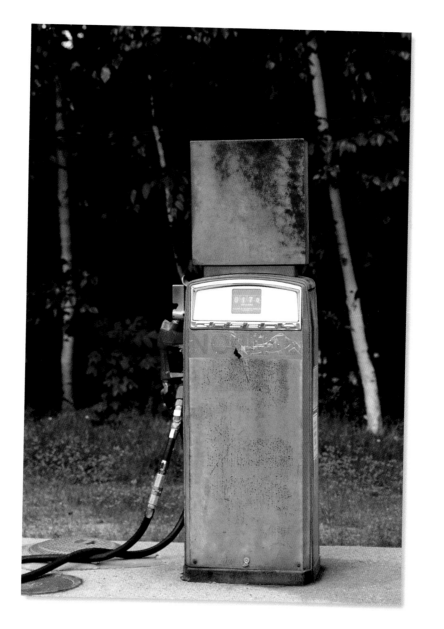

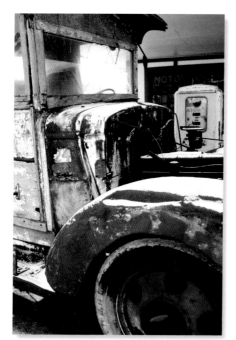

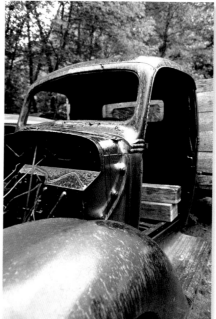

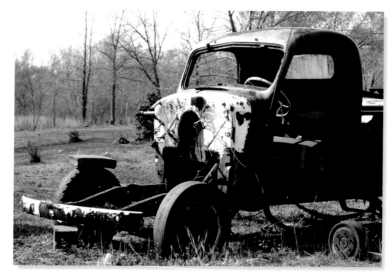

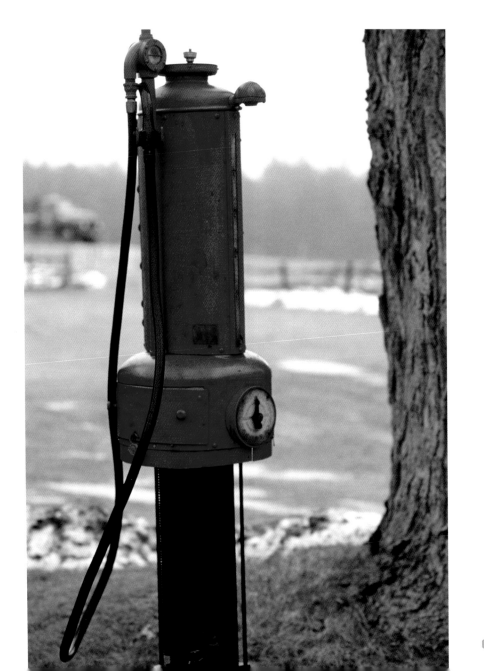

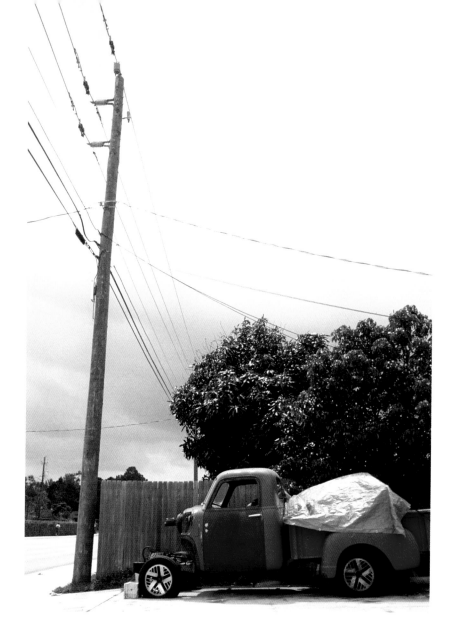